Telling Tales I

Classical Images from the
Dahesh Museum of Art

Telling Tales I

Classical Images from the Dahesh Museum of Art

Roger Diederen

❧

Dahesh Museum of Art

NEW YORK

2001

Dahesh Museum of Art

601 Fifth Avenue
New York, NY 10017
Telephone 212-759-0606
www.daheshmuseum.org

This book accompanies the exhibition
*Telling Tales I: Classical Images from the
Dahesh Museum of Art*
May 29 to September 29, 2001

Cover: François-Xavier Fabre, *Oedipus and the Sphinx*,
ca. 1806–08 (detail), see also fig. 9

Back cover: Jean-Jacques Pradier, *Standing Sappho*,
modeled 1848, cast ca. 1851 (back view), see also fig. 6

ISBN: 0-96547-936-6
Library of Congress catalogue no. 2001090375

Photography: Robert Mates; Orcutt & Van Der Putten
Design: Lawrence Sunden, Inc.
Printing: The Studley Press

Table of Contents

Foreword

Academic art of the 19th and early 20th centuries paid constant and reverent homage to the Western cultural legacy of ancient Greece and Rome. If the Renaissance of the 15th and 16th centuries saw an intensive new apprehension and assimilation of that legacy, then the 19th century remained the heir of pictorial, historical and theoretical ideals reborn in the Renaissance: namely, an emphasis on the human figure as the principal vehicle for pictorial expression; the primacy of the stories and myths that embody this cultural nexus; and a training system that passed along to each new generation expectations of the highest technical proficiency.

Acknowledgement of these academic ideals is explicit in exhibitions, educational activities and, most certainly, the collection policies of the Dahesh Museum of Art. From its inception, the collection has maintained a strong representation of work devoted to the classical legacy, and subsequent acquisitions have continued to strengthen this important area. Following *A Distant Muse* (2000), which featured Orientalist art from the collection, *Telling Tales I: Classical Images from the Dahesh Museum of Art* explores the great Greco-Roman heritage that so dominated artistic production during the 19th century. *Telling Tales I* is both a handbook of this aspect of the collection, featuring old favorites as well as important recent acquisitions, and the catalogue of an exhibition presented at the Museum in the Summer of 2001. It will be followed in the Fall of 2001 by *Telling Tales II: Religious Images in 19th-Century Academic Art*, also an exhibition and publication.

Roger Diederen, the Museum's Associate Curator, organized *Telling Tales I* and wrote the excellent text that describes the most significant ways that the 19th century interpreted classicism's cultural legacy. Viewers and readers will probably be surprised by the diversity of approaches and the persistence of a classical vision well into the 20th century. As the 21st century begins, there is a new appreciation of earlier academic art and a revival of these ideals in art education and artmaking today.

This catalogue would not be possible without the support of the Museum's Board of Trustees. They have steadfastly sustained all programs and the continuing development of the collection. I also extend warmest thanks to all members of the Museum staff.

J. David Farmer
Director

7

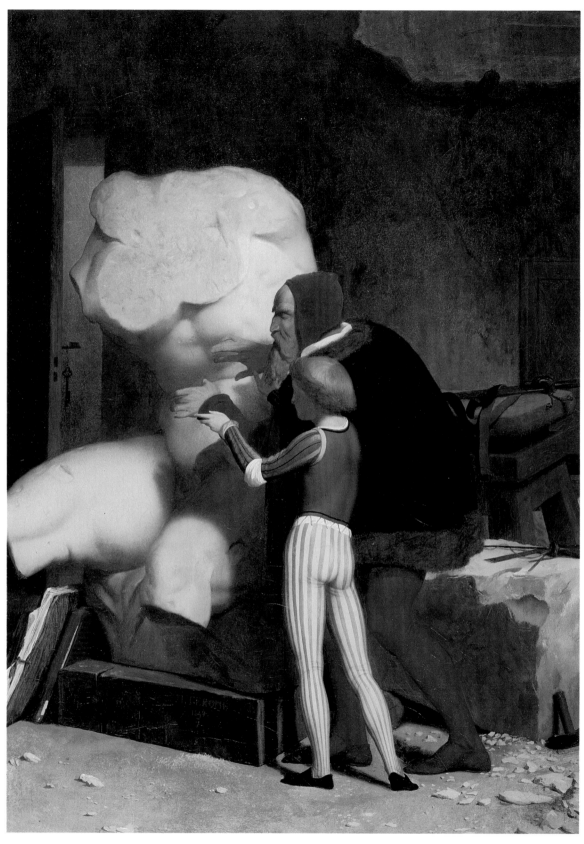

FRONTISPIECE, fig. 3. Jean-Léon Gérôme, *Michelangelo*, 1849. Oil on canvas, 52.1 x 37.5 cm (20½ x 14¾ in.).
Dahesh Museum of Art, 1999.8

Telling Tales I:
Classical Images from the Dahesh Museum of Art

THE ARTISTIC VOCABULARY developed by the ancient Greeks and Romans never truly lost its significance in the imagination of later painters, sculptors, architects and writers. Awareness of Classical art and literature persisted throughout the Middle Ages, and the very term Renaissance implies a rebirth of ancient culture. The amorous divertissements of gods and heroes felt very comfortable in a frivolous Rococo cartouche, as did the deconstructed column and pediment in postmodern architecture. Of course, one of the truest revivals of the ancient heritage, both in spirit and representation, was the Neoclassical movement of the late 18th and early 19th centuries. *Telling Tales I: Classical Images from the Dahesh Museum of Art*, however, explores these elements in the collection not in a strict Neoclassical sense but in a far wider range. Given the nature of the Museum's holdings, it is appropriate to investigate how creators of academic art in the 19th century adapted the Classical canon to their specific needs and aspirations.

The first section explores how ancient sculptures, or plaster casts after them, formed an integral part in the training of the academic artist. Charles Bargue's *Cours de Dessin* (1868–72), as well as Gérôme's *Michelangelo* (1849), bear witness to this principle in very different ways. And with his *Standing Sappho* (1848) the sculptor Pradier emulated his predecessors in a most formidable manner. A second group of works represents the countless tales comprising Greek mythology, which were evidently a prime source for any history painter, Fabre's *Oedipus and the Sphinx* (ca. 1806-08) being a key example. After the more rigid Neoclassical history painting began to lose its predominance, several historical genre painters started to recreate daily life in ancient Greece and Rome, as did Alma Tadema with *A Staircase* (1870). Finally, some works in the DMA's collection are prime examples of how the Classical canon could at times be greatly transformed. Jaroslav Čermák's unsettling, yet grandiose depiction of the abduction of a Herzegovenian woman, serves as a fascinating case study. Clearly derived from mythological antecedents, this 1861 "Salon machine" is not

only strongly informed by the Romantic and Orientalist movements but also contains socio-political and religious implications that still carry much significance today.

I. AFTER THE ANTIQUE

In the late 18th century, the notions of studying after Nature (*d'après la nature*) and after the Antique (*d'après l'antique*) were in a sense two sides of the same coin. In striving for a true imitation of Nature, the perfect form was not contained in an individual object, person, animal or plant, but in the idealized and faultless concept of it. Scholars such as Johann Joachim Winckelmann (1717-1768) perceived the art of the ancient Greeks and Romans as the most successful achievements of representing the sublime forms of Nature. He further argued that the Greeks were able to create such pure art as a result of the organization of their society, which he perceived as ideal. In light of these and related concepts, studying ancient art became one of the cornerstones in the artist's academic curriculum, and traveling to Italy in order to study the objects *in situ* became common practice. Institutionalized in the *Prix de Rome* competition, the French academy enabled its most promising students at the École des Beaux-Arts to spend several years at the Villa Medici in order to complete their artistic formation under the best possible circumstances, surrounded by the greatest masterpieces.

Thus, the role played by ancient sculptures cannot be overestimated. Given their material durability, they had survived the centuries in great numbers and were, together with architecture and pottery, the most tangible links with the ancient past. The sculptures' well-proportioned (human) forms came to represent the very essence of the academic ideal. Its guiding function was twofold: sculpture taught the perfect proportions and also provided many pieces of the historical and mythological puzzle of the cultures that produced these marvels. When, for example, Gérôme taught his first class at the École des Beaux-Arts in 1864, the model his students worked from was the antique statue of *Germanicus* (Paris, Musée du Louvre).[1] Gérôme may have used it primarily as a

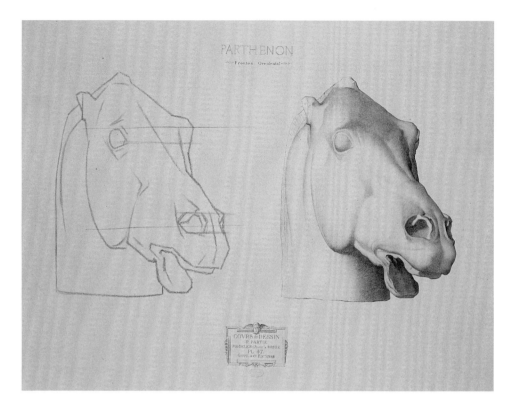

Fig. 1. Lithograph by Charles Bargue, after a drawing by Jean Lecomte du Nouÿ, for the *Cours de Dessin*, vol. I: *Modèles d'après la bosse*, plate 47, *Tête de cheval (Parthenon, Fronton Occidental)*, ca. 1868. Impression on gray paper, 47.1 x 61 cm (18½ x 23⅞ in.). Dahesh Museum of Art, 2000.8

form to be drawn, but he might also have discussed the military deeds of Tiberius's nephew. Moreover, sculptures were tireless models and, in the form of plaster casts, readily available in many sizes.

Gérôme was also involved in the publication of a printed drawing course, a tool that had become fairly common by mid-19th century in order to teach basic drawing skills. This famous course comprised some 180 lithographs by Charles Bargue (1824–1883), divided over three volumes published by Goupil & Cie from 1868 to 1872.[2] Gérôme, whose name appears in the title, was most likely in charge of the selection of subjects. The images provided students with many different examples of sculpture, as well as copies after paintings and drawings by Old Masters and contemporary artists. Even though Bargue is known as the lithographer of the *Cours de Dessin*, it has until now been impossible to determine which individual artists provided Bargue with the drawings for his plates. One of the lithographs in the DMA's collection has, in fact, been made after a drawing by one of Gérôme's students (fig. 1), Jean Lecomte du Nouÿ (1842–1923).[3] According to his biographer, Lecomte du Nouÿ submitted seven drawings to Bargue in order for them to be lithographed.[4] One of these is the sculpted head of one of the horses pulling the

chariot of the moon goddess Selene, which originally adorned the right corner of the East pediment of the Parthenon (plate 47 of the *Cours de Dessin*).[5] Lecomte du Nouÿ was also responsible for the drawing of a reclining figure identified as *Theseus* (plate 61 of the *Cours de Dessin*), another Parthenon sculpture. The artist's third secured design is of the *Belvedere Torso* (frontal view, plate 63 of the *Cours de Dessin*), one of the most famous sculptures of antiquity (Rome, Vatican Museums).[6] All these *Cours de Dessin* plates belong to the first volume entitled *Modèles d'après la bosse*. The term *ronde-bosse* refers to a form in the round, and in the arts implies sculpture or plaster casts. The challenge for the art student lay in properly rendering a three-dimensional form on a two-dimensional surface, by means of correctly drawing outlines in which areas of shadow were modeled to create depth and volume. Many plates of sculptures show a rudimentary outline of the general form of the model, such as the leg of *Germanicus* (fig. 2), next to a finished version of the same subject. The plates were not bound so that the student could attach them to the wall. This practice explains why few complete sets of the course survive.

In an entirely different mode, the *Belvedere Torso* plays an essential role in Gérôme's early mas-

terpiece *Michelangelo* (1849; fig. 3, frontispiece). Rather than informing the pose of some mythical god or hero, the sculpture serves as one of the main "characters" in a genre scene. Two years earlier, Gérôme had made his reputation at the 1847 Salon by exhibiting *The Cock Fight* (1846, Paris, Musée d'Orsay). This painting of a naked boy and girl watching two roosters fight, virtually launched the so-called *néo-grec* movement, challenging the traditional definition of history painting as the formal portrayal of noble and didactic subjects. Although similar to his *néo-grec* works, *Michelangelo* depicts an imaginary event concerning the life of the great Renaissance painter and sculptor, rather than a genre scene set in antiquity.[7] A young boy guides the hands of the old and apparently blind Michelangelo towards the ancient statue. Michelangelo is not known to have been blind, but he was reportedly a fervent admirer of the *Torso*, and his endorsement greatly propelled the work's reputation.[8] It even seems that the sculpture remained in its damaged form—rather than being restored with newly carved limbs as often occurred with other ancient statues—because Michelangelo himself did not feel qualified to perform the task.[9]

In this context, Gérôme's painting becomes a poignant tale of one of the greatest masters contemplating and revering his artistic roots, seconded by a younger generation that will continue the valued traditions. Furthermore, the picture contains references to the artistic profession in an academic sense. The young apprentice, the portfolios and tools refer indirectly to the concepts of learning and creation, both as an intellectual and sensory process. On a more suggestive but no less significant level, the composition has also been interpreted in the context of the bohemian atmosphere in which such early *néo-grec* artists as Gérôme, Henri Picou, Jean-Louis Hamon and Gustave Boulanger produced their art.[10] Painters, sculptors, writers and musicians regularly gathered in the studio building in the rue Fleurus, making it one of the more significant artistic centers of Paris. Given the liberal circumstances under which these artists interacted, combined with the reported sexual orientation of Michelangelo himself, a homoerotic reading of this painting seems appropriate as well.

It was not until 1878 that Gérôme seriously began sculpting. His picture *Working in Marble* (1890; fig. 4)[11] is a fine testimony to both this art form, and to his own sculpture *Tanagra* (1890, Paris,

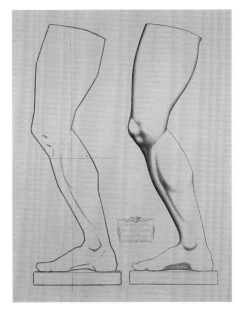

Fig. 2. Lithograph by Charles Bargue for the *Cours de Dessin*, vol. I: *Modèles d'après la bosse*, plate 25, *Jambe du Germanicus (profil)*, ca. 1868. Impression on gray paper, 61 x 47.1 cm (23⅞ x 18¾ in.). Dahesh Museum of Art, 2000.10

Musée d'Orsay). A stately female nude personifies the ancient Greek village of Tanagra, famous for the figurines produced in great numbers by its artisans and in the 19th century unearthed by archaeologists. In the painting it is not immediately evident that the figure is seated on crumbling stones with an excavation tool, referring to the discipline of archaeology. The discovery of many such polychrome terracotta statuettes reinforced the notion that Classical sculpture originally must have been colored. Gérôme, in his characteristic attempt towards archaeological correctness in his art, tinted the hair, lips and eyes of his marble *Tanagra*, causing quite a sensation at the 1890 Salon. The statue of the hoop dancer seen on the right refers to another sculpture by Gérôme and is his interpretation of the Tanagra figurines. The bust on the sideboard is Gérôme's sculpture of the moon goddess *Selene*, and on the back wall hangs a version of his painting *Pygmalion and Galatea* (whereabouts unknown). Radiographic examination of *Working in Marble* has revealed that this painting within a painting covered an earlier depiction of feline animals. The superimposed mythological scene, however, is more appropriately related to the main subject. It refers to Pygmalion, King of Cyprus, who, disappointed by mortal women, carved an ivory statue of his ideal and fell in love with it. In answer to his prayer, Aphrodite brought the sculpture to life

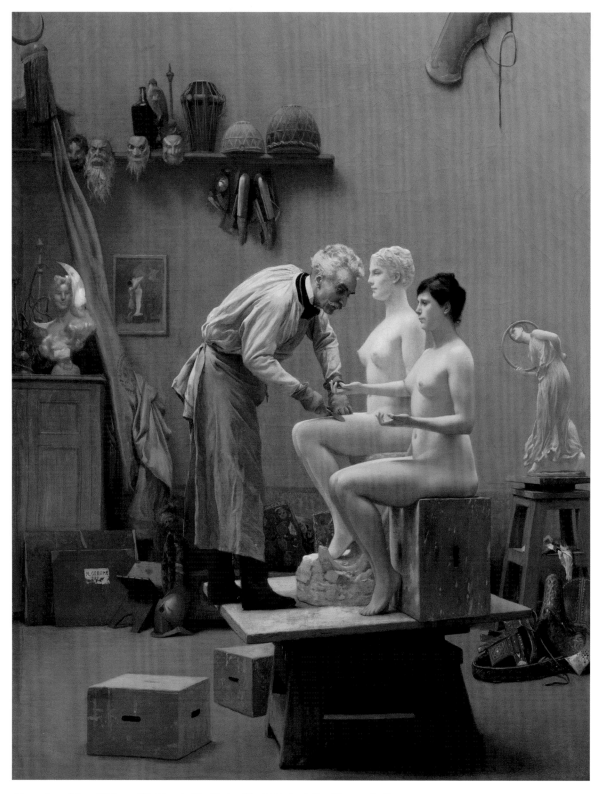

Fig. 4. Jean-Léon Gérôme, *Working in Marble* (or *The Artist Sculpting Tanagra*) 1890.
Oil on canvas, 50.5 x 39.5 cm (19⅞ x 15⁹⁄₁₆ in.). Dahesh Museum of Art, 1995.104

Fig. 5. Louis-Robert Carrier-Belleuse, *The Sculptor's Studio*, ca. 1870. Oil on canvas, 64.8 x 89.5 cm (25½ x 35¼ in.). Dahesh Museum of Art, 1996.9

and Pygmalion married her. Her name Galatea, by which the sculpture came to be known, is a post-classical addition, similar to Gérôme's invention of adding a Cupid with bow and arrow. *Working in Marble* not only testifies to Gérôme's endeavor of vitalizing his sculptures by coloring them, but also refers to the complex issues of art and its traditions, and reflects on the notions of reality versus representation.[12]

Another painted interior of a sculptor's studio in the DMA collection is the work by Louis-Robert Carrier-Belleuse (1848–1913), the son of the better known sculptor Albert-Ernest Carrier-Belleuse (1824–1887), whose atelier is depicted here (fig. 5). Both works belong to an old tradition of such studio scenes. Although they are intriguing documents of artistic life, there is a risk of taking these works too literally. Artists often created them for how they wanted their profession to be perceived, but they can still reveal certain studio practices. The many plaster casts that are hanging from the wall function as the equivalent of preparatory drawings for a painter. Of course, painters also used such three-dimensional models, as is shown, for example, in the various studio interiors by Michael Sweerts (1618–1664),[13] and is also implied by the images of the *Cours de Dessin* plates.

Louis-Robert was both a painter and a sculptor and trained with his father before studying under Alexandre Cabanel (1823–1889) at the École des Beaux-Arts. It is tempting to assume that the young man seated in the right foreground is a self-portrait of the artist.[14] Albert-Ernest stands besides two of his sculptures, one of which can be securely identified: the work in the right background called *L'enlèvement*, or *The Abduction of Hippodamia*, from ca. 1871.[15] Pirithous, King of the Lapiths, invited the centaurs to attend his marriage to Hippodamia. After a wild celebration during which wine flowed freely, the guests began lusting after the bride, a battle ensued and a centaur abducted Hippodamia. The other sculpture seen most prominently in the painting relates closely to, yet differs distinctively from, another work by Albert-Ernest called *Bacchante Offering a Libation to a Bacchic Term*. He began modeling this work in 1860, and produced a marble statue that was eventually purchased by Napoleon III and presented to the Tuileries Gardens. The bacchante in this sculpture has her right arm fully stretched in order to present her offering to the term. In the sculpture in the painting, however, the head of the term is much closer to the bacchante and both her arms reach out to him. Since Carrier-Belleuse made variations of his initial

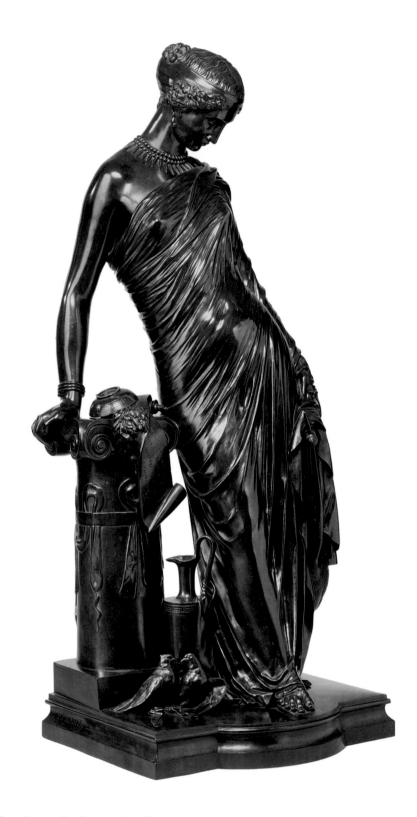

Fig. 6. Jean-Jacques Pradier, *Standing Sappho*, modeled 1848, cast ca. 1851. Bronze, 86 x 37 x 33 cm (33⅞ x 14½ x 13 in.). Dahesh Museum of Art, 2001.5

sculpture with this theme, the sculpture so prominently seen in the painting may well be one of these other versions.[16] Placing the work around 1870 seems for now most appropriate, given the date of the sculpture *L'enlèvement*.

One of the great 19th-century classizing sculptors, Jean-Jacques Pradier (1790–1852) is represented in the Museum's collection by a rare cast of his large *Standing Sappho* (fig. 6, and back cover).[17] First shown in bronze at the 1848 Paris Salon (Royal Collection, Isle of Wight, Osborne House), the Greek poet graciously leans against an Ionic column, holding a lyre in her left hand as the attribute of her art and flanked by various offerings to Venus and a pair of cooing doves. A scroll hangs down from the column reading the Greek verses from her *Ode to Venus* (Sappho I, 25 8): *"Goddess, come again today, take away my cruel torments, make the wishes of my heart come true, do not refuse me your help."*

In 1849, a second version of this work was cast in solid silver and served as the first prize in a lottery for the benefit of French artists (Barnard Castle, UK, the Bowes Museum). The present cast is the other known version of the large *Sapho debout* made in bronze. Under Pradier's supervision, the founder Victor Paillard probably cast it at the time of the 1851 London Great Exhibition, where he presented a smaller version in silver and gilt bronze. The Museum's cast has the same attributes, dimensions, and dark patination of the 1848 model, whereas many later and smaller casts no longer feature such attributes as the doves and vase at her feet, or the inscribed verses on the scroll. When the critic Théophile Gautier reviewed the work at the Salon, he placed it entirely in the context of Pradier's relation to antiquity:

> In following the Ancients, Pradier, who does not like to mar the beauty of the features by expressions of joy or sorrow, has never created such a significant physiognomy; usually, he concentrates life in the torso which is for him the most important part of the human body. The predominance of the head over the rest of the body is a spiritualist and Christian sentiment not known in antiquity, and Pradier is a pure pagan, worshipper of Zeus, Hera, Poseidon, and above all Aphrodite. This time, as the drapery covered the parts that he excels in rendering, he gave more importance to the mask, and the thought con-

tracts the bronze eyebrow; besides, Sappho the great poetess deserved a soul to be lodged behind her forehead, and the sculptor has left her enough beauty to make the leap from the Leucadian rock incomprehensible. [...] This half-life-size statue, if suitably oxidized and coated with verdigris by staying a long time under the earth or in the sea, and thereby receiving an antique patina, could pass for a true Greek or Roman work and would fetch incalculable sums."[18]

The Dahesh Museum of Art collection further includes two paintings in which "Classical" sculpture of some sort plays a role. In an all but Classical setting, the Italian genre painter Camilio Innocenti (1861–?) recreated a Rococo painter's studio in which an artist is seated behind an easel while working on

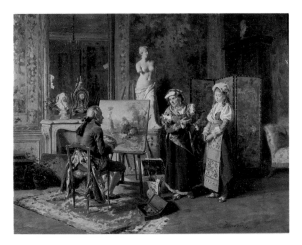

Fig. 7. Camilio Innocenti, *The New Model*. Oil on panel, 29.2 x 40.6 cm (11½ x 16 in.). Dahesh Museum of Art, 1997.20.

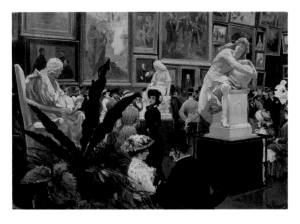

Fig. 8. Wilhelm Gause, *At the Vienna International Art Exhibition of 1882*, 1882. Oil on paper, laid down on canvas, *grisaille*, 21 x 31.1 cm (8¼ x 12¼ in.). Dahesh Museum of Art, 1997.45

15

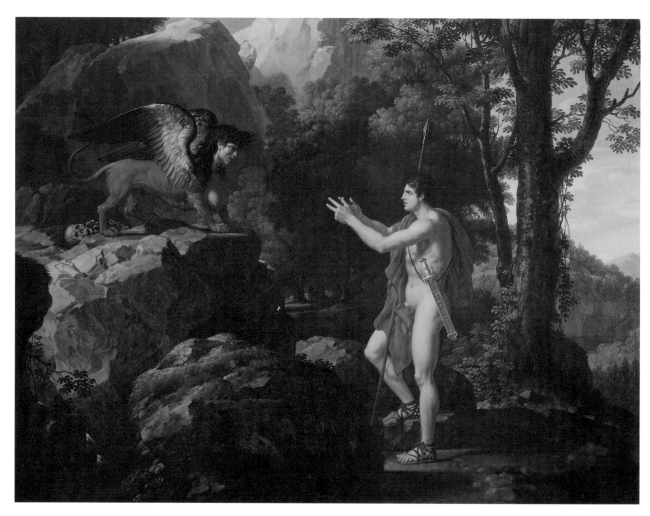

Fig. 9. François-Xavier Fabre, *Oedipus and the Sphinx*, ca. 1806–08. Oil on canvas, 50.2 x 66 cm (19⅘ x 26 in.).
Dahesh Museum of Art, 2001.3

a landscape featuring two peasant women, as an old woman introduces a demure young girl dressed in a colorful folkloric costume (fig. 7). Apparently she is there to serve as the painter's new model. Even though Innocenti created this composition primarily to show his proficiency in depicting a richly decorated interior, a plaster cast of the famous *Venus de Milo* (Paris, Musée du Louvre)[19] literally stands tall over the scene as the ultimate representation of eternal female beauty, the very criterion for which the young girl seems to have been chosen.

At the Vienna International Art Exhibition of 1882 (fig. 8), Wilhelm Gause's painted grisaille "snapshot" of that event, prominently features Charles-René de Paul de Saint-Marceaux's *Genius Guarding the Secret of the Tomb* (1879, Musée d'Orsay).[20] This large marble earned the sculptor the First Medal at the Paris Salon of 1879, as well as one of only two Medals of Honor that were awarded that year. In 1882, the marble was displayed in the French section of the Vienna exhibition. As a Prix de Rome laureate Saint-Marceaux had studied in Rome, and visited Florence among other Italian cities. Consequently, he was much affected by the works of Michelangelo, such as the frescoes in the Sistine Chapel and the monumental tomb of Lorenzo de' Medici in Florence's San Lorenzo. Michelangelo's influence is revealed in the complicated modeling of this seated Genius (a guardian spirit in Roman religion), protecting an urn with his arms and turned upper body. Saint-Marceaux's work is in fact a veritable amalgamate of Michelangelo's art, not only his paintings (such as the genii on the Sistine ceiling) but also his sculptures (for example, the personification of *Day* from the Medici Chapel, as well as *The Genius of Victory* in the Palazzo Vecchio).[21] Here it is evident once more that Michelangelo had long since reached an equally exemplary status as the ancient Greek sculptors themselves, and with works like Saint-Marceaux's *Genius*, the Classically rooted legacy continued throughout the 19th century.

II. MYTHOLOGY

The symbolic stories that comprise Greek and Roman mythology have traditionally sought to explain such guiding principles of human existence as life and death, as well as other universal concepts. Together with scenes from Classical history and the

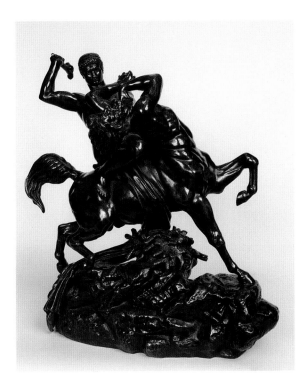

Fig. 10. Antoine-Louis Barye, *Theseus Combating the Centaur Bianor*, modeled ca. 1850. Bronze, 41 x 16.5 x 40.5 cm (16¼ x 6½ x 16 in.). Dahesh Museum of Art, 1995.110

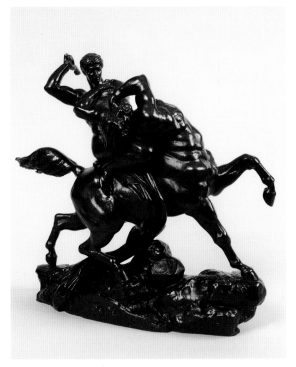

Fig. 11. Antoine-Louis Barye, *Theseus Combating the Centaur Bianor* (sketch), modeled ca. 1846–48. Bronze, 34 x 15 x 35.5 cm (13½ x 6 x 14 in.). Dahesh Museum of Art, 1995.15

Bible, mythological scenes were the main sources for the history painter and sculptor. In the academic tradition this was regarded as the highest genre in art, as it depicted the human passion and intellect in elaborate compositions. Towards the end of the 18th century, the frivolous forms and subjects that define Rococo aesthetics began to be replaced by the more restrained language of Neoclassicism, focusing on the essence of narrative and composition. The preferred themes related to the heroic action of mankind, as opposed to the less profound amorous intrigues among the gods.

François-Xavier Fabre's *Oedipus and the Sphinx* (ca. 1806-08; fig. 9) is a splendid example of true Neoclassical painting.[22] This pupil of Jacques Louis David (1748–1825) portrayed the dramatic moment when the deadly Sphinx confronts the young Oedipus with her riddle: "What is that which at dawn walks on four legs, at midday on two, and in the evening on three?" He masterfully replies "Man," who as an infant crawls on all fours, as an adult stands on two feet, and with old age uses a staff as a third limb. Fabre placed Oedipus in a beautifully staged landscape reminiscent of Nicolas Poussin (1594–1665), gave him the likeness of the prototypical, well-formed Greek hero, and had him gesture dramatically with three fingers stretched, leaving no doubt that he would answer the riddle successfully. It is not surprising that this profound story about a test at one of life's many crossroads was ideally suited for Neoclassical artists. The tale of Oedipus provided not only Fabre with the subject for several of his paintings, but Jean-Auguste-Dominique Ingres (1780–1867) also treated the hero's trial while residing in Rome in 1808 (Paris, Musée du Louvre).

Another confrontation between a hero and a mythical creature is represented in two closely related sculptures by Antoine Louis Barye (1796–1875), best known for his more Romantic bronzes of animals. A student of the Neoclassical sculptor François Joseph Bosio (1768–1845),[23] Barye had a thorough grounding in the Classical tradition, even though he ultimately completely departed from his teacher's style. Ovid recounted the Battle of the Lapiths and the Centaurs in his *Metamorphoses*. Book XII describes how Theseus, ruler of Athens, helped the king of the Lapiths by violently slaying the centaur Bianor. Barye exhibited a large plaster of *Theseus Combating the Centaur Bianor* at the Salon of 1850, after which bronzes in various sizes were cast (fig. 10).[24]

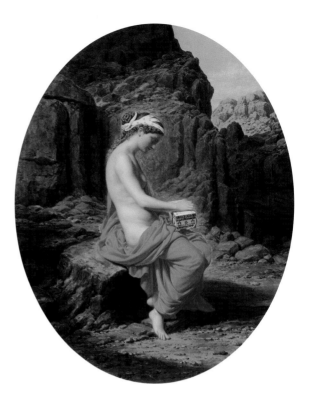

Fig. 12. Paul Césaire Gariot, *Pandora's Box*. Oil on panel, oval, 38.7 x 28.6 cm (18 x 14¼ in.). Dahesh Museum of Art, 1996.25

Barye must have been aware of the metopes from the Parthenon depicting the Greek legend, but the specific modeling of the death blow delivered by the Greek hero is recognizable as a borrowing from the marble *Hercules Slaying a Centaur* (1595–1600, Florence, Loggia dei Lanzi) by the Mannerist sculptor Giovanni Bologna (1529–1608).[25] Around 1846–48, Barye had already made a smaller sketch of the same subject which was eventually also cast (fig. 11). Both versions differ substantially, resulting in a slightly more horizontally oriented composition of the later work. The rock formation beneath the horse is somewhat higher, the centaur's upper torso leans further back, and its left front leg is more contracted. The tip of the tail is curled inwards, and the centaur's hair flows differently than in the earlier *modello*. In all, these changes give the later work a greater sense of agony and better express the fierceness of this battle.

The tranquil image of a woman in profile by Paul Césaire Gariot (1811–1880) (fig. 12) stands worlds apart from the violent encounter between hero and centaur. Scantily draped in red and with a ribbon in her hair, she is about to open a box. As calm as the image may seem at first, recognition of the subject

immediately generates a certain anxiety within the viewer. Zeus created Pandora, the first woman, in order to punish humans after Prometheus had given them fire. Pandora ("all gifts") carried a jar that she was not allowed to open, as it contained the evils and diseases that had been previously unknown to mankind. When she did open the jar after all, the disasters escaped and the legendary Golden Age ended. Only Hope remained as a consolation for mortals. In the ensuing tradition of this story, Pandora's jar became confused with the box that Psyche (the soul) was forbidden to open. In his painting, Gariot succeeded in evoking a sense of concern over the inevitable fate that looms over the human race by framing the charming woman in an eerily barren, almost apocalyptic landscape.

Beyond providing artists with intriguing narratives for their compositions, mythological scenes also rationalized depictions of the nude human body. Henry Pierre Picou (1824–1895) was one of Gérôme's early allies in the *néo-grec* movement, but *Andromeda Chained to a Rock* (1874; fig. 13) is not one of his more typically lighthearted excursions into the realm of love, filled with dallying young maidens and putti. Instead, he created a fervent depiction of Perseus, the warrior son of Zeus and the mortal Danaë, rescuing Andromeda from a vicious sea monster. Perseus brandishes the severed head of Medusa, which had the power to turn all who gazed upon it into stone. No doubt lingers, however, that Picou employed this myth in order to present the tormented Andromeda in all her voluptuous beauty. Similarly, Luc Olivier Merson (1846–1920) painted Diana, the goddess of the hunt, as a female nude in a luscious forest setting (fig. 14), as did Jules Joseph Lefebvre (1836–1911) in his minute rendition of the subject (fig. 15). At the Salon of 1864, Auguste Gendron (1817–1881) exhibited *The Nymphs at the Tomb of Adonis*, a composition filled with female nudes (fig. 16). Adonis was a beautiful young hunter who became the lover of Aphrodite (Venus), and was killed by a wild boar on one of his hunting trips. The Salon catalogue provided the visitor with a brief text after the picture's title: "When the night star shines on this foliage, a soft sleep follows their moaning."[26]

In yet a wholly different retrospective mode, Ignaz-Marcel Gaugengigl's (1855–1922) *The Painter* (fig. 17) shows an 18th-century artist contemplating how to proceed with his swooning "Venus and Cupid." This type of mythological subject matter was perceived as ideally suited for recreating a genre scene set in Rococo times. This German artist eventually moved to the United States, where, not surprisingly, he was dubbed the "Meissonier of America." In a similar historicizing 18th-century style, Gabriel Ferrier (1847–1914) drew a circle of flying putti (fig. 18), which seems to be a study related to his ceiling of the grand dining room of the Hôtel du Palais d'Orsay (a part of the present Musée d'Orsay), painted in 1900. Although this particular composition from the drawing was ultimately not repeated in the final ceiling.[27] Similarly, Louis Ardisson (active 1860–1890) exquisitely carved two wooden bas-reliefs in a Roco-

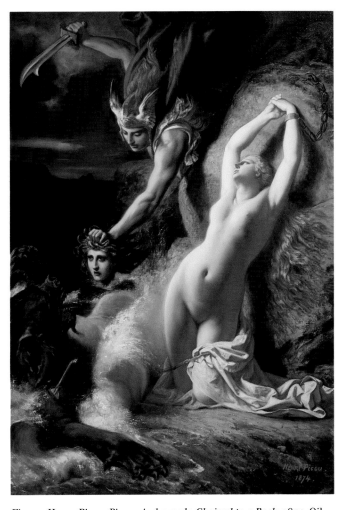

Fig. 13. Henry Pierre Picou, *Andromeda Chained to a Rock*, 1874. Oil on canvas, 120.3 x 84.8 cm (47⅜ x 33⅜ in.). Dahesh Museum of Art, DM 730

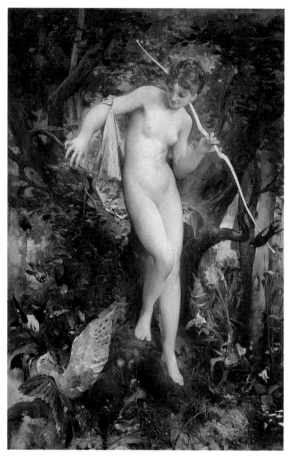

Fig. 14. Luc Olivier Merson, *Diana the Huntress*, 1878. Oil on canvas, 68.6 x 43.8 cm (27 x 17¼ in.). Dahesh Museum of Art, DM 436

Fig. 15. Jules Joseph Lefebvre, *Diana*. Oil on panel, 30.5 x 26.7 cm (12 x 10½ in.) Dahesh Museum of Art, 1996.19

Fig. 16. Ernest Augustin Gendron, *The Nymphs at the Tomb of Adonis*, ca. 1864. Oil on canvas, 56.8 x 100 cm (22⅜ x 39⅜ in.). Dahesh Museum of Art, DM 437

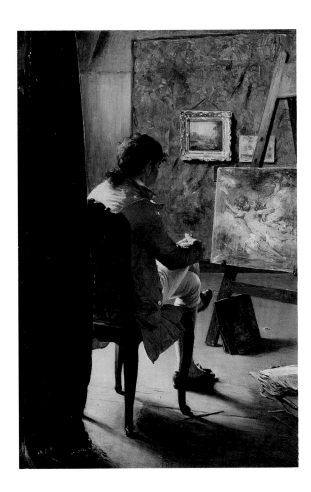

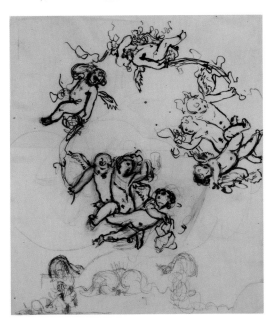

Left, Fig. 17. Ignaz-Marcel Gaugengigl, *The Painter*, ca. 1883. Oil on panel, 20.6 x 13.5 cm (8¹⁄₁₆ x 5⅜ in.). Dahesh Museum of Art, 1996.2

Below, Fig. 18. Gabriel-Joseph-Marie-Augustin Ferrier, *Putti* (study for a ceiling decoration in the dining room at the Palais d'Orsay), ca. 1900. Ink on paper, 34.6 x 39.4 cm (13⅝ x 15½ in.). Dahesh Museum of Art, Gift of Shepherd Gallery, New York, 1995.118

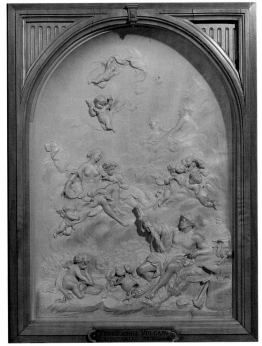

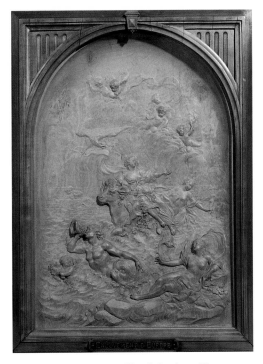

Fig. 19. Louis Ardisson, *Venus and Vulcan*, 1878. Carved wood bas-relief, 52.1 x 41.1 cm (20½ x 16³⁄₁₆ in.). Dahesh Museum of Art, 1999.17.1

Fig. 20. Louis Ardisson, *The Abduction of Europa*, 1879. Carved wood bas-relief, 51.6 x 40.8 cm (20⁵⁄₁₆ x 16¹⁄₁₆ in.). Dahesh Museum of Art, 1999.17.2

co style representing *Venus and Vulcan* (fig. 19) and *The Abduction of Europa* (fig. 20). The first was exhibited at the 1878 Universal Exhibition and won him a bronze medal. Ardisson is known to have made carvings after works by such 18th-century painters as Boucher and Fragonard, usually depicting amorous mythological scenes.

Even though Émile René Ménard's (1862–1930) *The Bath of Diana* (ca. 1920; fig. 21)[28] seems to be a similar ploy to justify mild eroticism under the pretext of Classical mythology, his work is, in fact, some-

depicting more generic visions of Arcadia. Ménard attempted to convey the characteristics of the Golden Age of Greek civilization by representing statuesque male and female nudes in serene landscapes. He was also deeply interested in the appearances and effects of nature. Many of his works include a pond or a river, enabling him to depict bathing figures and to suggest the reflections of trees, clouds and the setting sun. Often generic titles such as *Rêve Antique* completed Ménard's idyllic creations of a pure and unaffected society. The same figural group that

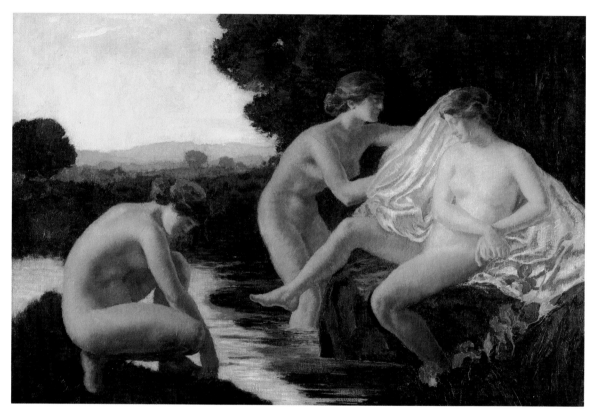

Fig. 21. René Ménard, *The Bath of Diana*, ca. 1920. Oil on canvas, 85.1 x 123.2 cm (33½ x 48½ in.). Dahesh Museum of Art, DM 38

what different. Ménard grew up in a profoundly artistic and intellectual milieu. His father, René-Joseph, is best known as a critic who headed the influential *Gazette des Beaux-Arts*, and Théophile Gautier characterized his uncle, the pagan philosopher Louis Ménard, as an Athenian born two thousand years too late. Given this background it should be no surprise that René Ménard aspired to paint in a Classical tradition that once again prospered during the 1890s. Initially he chose his subjects from the Bible and Classical mythology, but soon reverted to

appears in this picture recurs in another composition with two additional female nudes in a more expansive landscape.[29] That work is dated 1920 and could help place the present picture in the artist's chronology. Ménard's oeuvre is a good example of how the Classical vocabulary continued to inspire artists well into the 20th century, and how such works form a bridge to the Symbolist movement.

The Dahesh Museum of Art owns three preparatory works by the eminent Victorian painter Frederic, Lord Leighton (1830–1896), one drawing and two oil

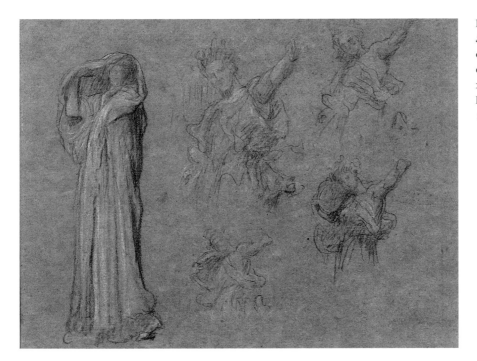

Fig. 22. Frederic Leighton, *Studies for "Bacchante,"* ca. 1892. Charcoal and chalk on gray paper, 24.5 x 32 cm (9¹¹⁄₁₆ x 12⅜ in.) Dahesh Museum of Art, 1999.6

sketches. Leighton made countless preparatory chalk drawings for his oil paintings. The Museum's sheet contains five studies, including a standing draped figure on the left that has not yet been related to a final composition (fig. 22). The four remaining drawings are all identifiable exercises for the upper body of a bacchante, in a painting called *Bacchante* (ca. 1892).[30] A bacchante is a female devotee of Bacchus, or Dionysus, popularly the god of wine but originally the god of fertility. The Museum's two oil sketches are related to some of Leighton's grandest works, processional compositions based on Greek literature. The study for *The Syracusan Bride Leading Wild Beasts in Procession to the Temple of Diana* (ca. 1865; fig. 23) is derived from the second *Idyll* of Theocritus, whereas Homer's *Iliad* inspired *Captive Andromache* (ca. 1886; fig. 24). Yet, Leighton did not adhere to the main narrative, preferring to select his themes from marginal incidents. The *Syracusan Bride* represents a briefly mentioned procession of wild animals and young women to the grove of Diana, while *Captive Andromache* depicts Hector's premonition of his wife's fate should he be killed in battle. His prediction comes true and she is forced to perform one of the lowest chores—filling her own water pitcher among the ordinary people. The luxuriant brushwork of these exquisitely suggestive oil sketches is a far cry from the careful finish of the enormous paintings they preceded.[31]

Unlike some of the works discussed here, the English painter Briton Rivière (1840–1920) did not conceive of his *Aphrodite* (fig. 25) for the subject's erotic potential. He chose to represent the goddess of love in an unusual scene suggested by one of the Homeric Hymns (8th–6th centuries BC), enabling him to depict animals. A label written by the artist, attached to the reverse of this impressive work reads that specific poem:

Aphrodite.

There clad herself in garments beautiful
The laughter loving goddess. Gold-adorned
She hasted on her way down Ida's Mount,
Ida, the many-rilled, mother of wild beasts
and in her train, the grey wolf and the bear,
the keen eyed lion and the swift fooled pard,
that hungers for the kind, all fawning came.

Homeric Hymn to Aphrodite.

Rivière reveled in painting animals, an extremely popular genre with his British audience, and became known as the successor to the country's leading *animalier*, Edwin Landseer (1802–1873). By infusing his passion for animals with a mythological element, he elevated the lowlier genre to a true history painting. After the picture was shown at the 1902 Royal Academy exhibition, a critic from *The Art Journal* wrote: "We can hardly look at this 'Aphrodite'

Fig. 23. Frederic Leighton, Study for *The Syracusan Bride Leading Wild Beasts in Procession to the Temple of Diana*, ca. 1865. Oil on canvas, 13.3 x 41.9 cm (5¼ x 16½ in.). Dahesh Museum of Art, 1998.10

Fig. 24. Frederic Leighton, Study for *Captive Andromache*, ca. 1866. Oil on panel, 20 x 40.6 cm (7⅞ x 16 in.). Dahesh Museum of Art, 1996.26

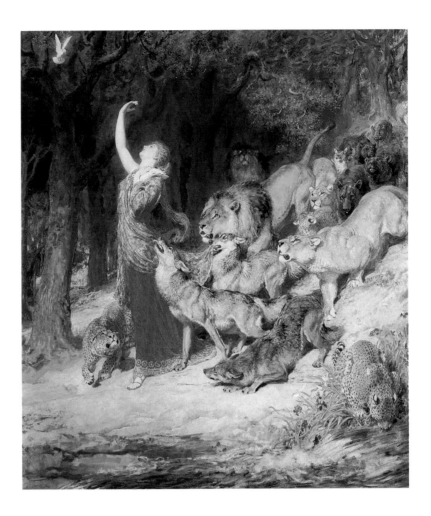

without recalling the woodland throng in Titian's great *Bacchus and Ariadne* of the National Gallery."[52]

III. CLASSICAL GENRE PAINTING

The Dutch-born Lawrence Alma Tadema (1836–1912) was undoubtedly the foremost Classical genre painter in Britain. Rather than addressing ancient culture by depicting heroic myths, he sought—like the *néo-grecs* in France—to revive antiquity on a more intimate and personal level. Extremely popular with collectors, Alma Tadema typically composed scenes of daily life in ancient Rome, in an effort to depict people of flesh and blood rather than superhuman heroes or gods. He became famous for his unparalleled technical ability to depict various materials, marble in particular. Even though Leighton's oil sketches represent fairly obscure subjects, they still rest on the great literary tradition of the ancient Greeks, and the related final paintings are of epic proportions. Alma Tadema's drawn preparatory

study for *A Reading of Homer* (fig. 26) on the contrary, refers to the supposed author of the *Iliad* and *Odyssey* only in the title. *A Reading of Homer* (1885, Philadelphia Museum of Art) is one of the artist's key pictures, and the drawing supposedly represents one of its first drafts. An inscription on the reverse of the drawing by the dealer Charles Deschamps, dated 1902, reads: "*One of the ideas L. Alma Tadema had for a picture "A Reading of Homer" to be submitted to Mr. H[enr]y Marquand of New York, who subsequently commissioned Tadema to paint him a picture of the subject, but of which the composition was quite different.*" Deschamps was the nephew of the famous dealer Ernest Gambart, an extremely influential figure in the development of the 19th-century art market. Alma Tadema, however, did not completely discard the idea he had jotted down on the Dahesh drawing as he repeated the exact composition of the two girls on the left in a later picture called *Love's Votaries* (1891, Newcastle-upon-Tyne, Laing Art Gallery).[53]

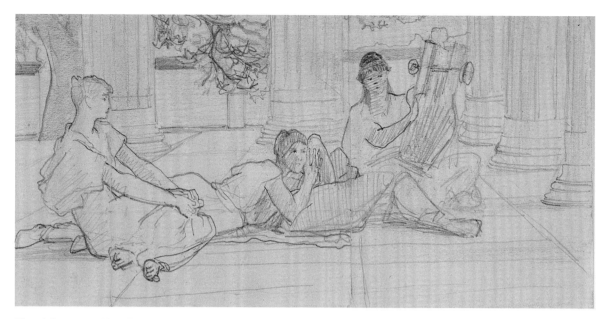

Fig. 26. Lawrence Alma Tadema, First concept for *A Reading from Homer*, ca. 1884–5. Pencil on paper, 11.4 x 22.9 cm (4½ x 9 in.). Dahesh Museum of Art, 1997.2

Painted in 1870, *A Staircase* (fig. 27) is a marvelously peculiar specimen of Alma Tadema's art to which he awarded the opus number LXXXIV.[34] The picture is fairly small, and the artist posed himself a formidable challenge in dealing with such an unusually shaped panel. He succeeded splendidly. His decision to paint four women in Roman dress ascending his signature marble staircase results in a most striking image. The painting is contained in its original frame, which to a certain extent forms part of the composition. The two Classical columns on either side expand upon the implied architectural space and somehow compensate for the narrow width of the panel. Together, the starkly elongated format, the figures seen from the back, and the generic title all construct an enigmatic image that has true cinematographic qualities. The remarkable manner in which several figures are cut off by the frame, and their gracious poses suggest knowledge of Japanese art, which was extremely popular in Europe at the time, mainly in the form of prints.

Alma Tadema submitted *A Staircase* as a lottery prize to a London exhibition for the Benefit of the Distressed French Peasantry in districts occupied by the German army during the Franco-Prussian war (1870–71). On December 3, 1870, *The Illustrated London News* called upon artists to send their pictures to the gallery of the Society of British Artists in Suffolk Street, rather than the famous French Gallery, run by

the dealer Gambart, which did not have sufficient space.[35] The article further read: "The exhibition will open on the 17th inst. Baron Gudin, and Messrs. Gérôme, R. Fleury, Heilbuth, Yvon, Schreyer and Alma-Tadema, with the Academicians E. M. Ward, Elmore, Calderon, and Frith are among those who have promised contributions." An attempt at a first oeuvre catalogue by the artist's Dutch friend Carel Vosmaer dates *A Staircase* precisely to December 10 1870.[36] The small size of the picture may thus also be partially explained by the fact that this work was seemingly a last-minute creation. On December 24, the journal followed up with a brief account of the exhibition.[37] Private collectors had lent important Old Masters from their homes, while artists and some other individuals donated pictures to raise money. Alma Tadema's participation to this event reveals the artist's personal involvement with the social circumstances of his time, and dispels the notion of some critics that he merely buried his head in the Pompeian sand.

The works by Charles Edward Perugini (1839–1918) and Luigi Bazzani (1836–1927) are other examples of Classical genre pictures. Perugini, who was born in Naples, first trained in Italy, then in Paris under Ary Scheffer (1795–1858), and moved to London in 1863. There he is said to have worked as an assistant to Frederic Leighton, who financially supported him. Perugini exhibited regularly at the Royal

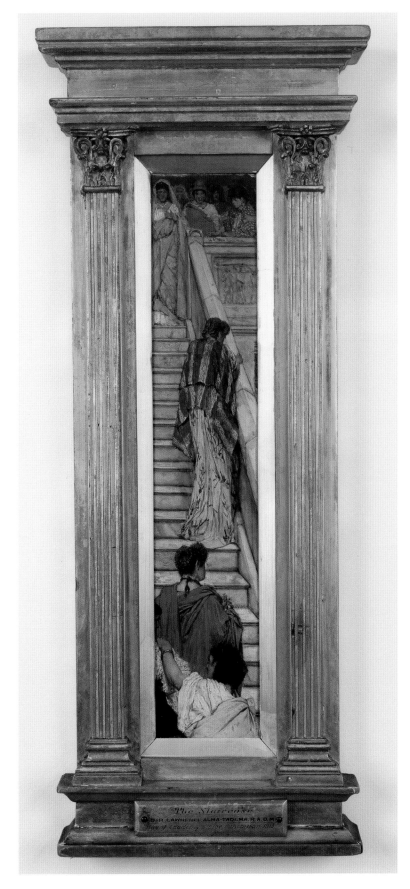

Fig. 27. Lawrence
Alma Tadema,
A Staircase, 1870.
Oil on panel, 42.5
x 9.5 cm (16¾ x 3¾
in.). Dahesh
Museum of Art,
2000.18

Fig. 28. Charles Edward Perugini, Sketch for "*The Green Lizard*," ca. 1902. Pencil and oil on artist's board, 16 x 25.1 cm (6⁵⁄₁₆ x 9⅞ in.). Dahesh Museum of Art, 1997.8

Fig. 29. Luigi Bazzani, *A Pompeian Interior*, 1882. Oil on panel, 38.7 x 28.6 cm (28¼ x 22 in.). Dahesh Museum of Art, 1996.24

Academy, where in 1902 he showed a painting called *The Green Lizard* (present whereabouts unknown). The work in the DMA collection is a preparatory sketch for that picture (fig. 28). Bazzani was one of Italy's foremost Classical genre painters and taught at the academy in Rome. He would certainly have visited Pompeii in order to study the remnants of the ancient civilization he so often depicted. There he would have seen the marble table portrayed in his painting (fig. 29), standing next to the impluvium of the Casa di Meleagro. Around 1865 the photographer Giorgio Sommer had recorded this very table with his camera, and a print of it belonged to Alma Tadema, who subsequently portrayed the same object in a picture (*Glaucus and Nydia*, 1867, Cleveland Museum of Art), inspired by Edward Bulwer, Lord Lytton's popular novel *The Last Days of Pompeii* (1834).[38] Alma Tadema used his collection of some 5000 photographs of ancient objects and architecture as a reference tool in order to make his compositions as historically accurate as possible.[39] Like Alma Tadema, however, Lord Lytton was also aware of the difficulties in reviving such ancient civilizations. In the preface to his extremely popular novel, he argued that one could only do so by giving "a just representation of the human passions and the human heart, whose elements in all ages are the same!"[40]

IV. TRANSFORMATIONS OF THE CLASSICAL CANON

This final section addresses how the Classical canon has at times been altered greatly without completely denying its roots. The underlying principle was not a rebellion against the traditionally accepted form, but a different interpretation of it. As a *Prix de Rome* laureate in 1850, Adolphe-William Bouguereau (1825–1905), for example, spent several years studying ancient art as well as the Renaissance masters in Italy. Among the most accomplished academicians of his time, he had a heartfelt respect for the legacy of his artistic predecessors. Apart from his many grandiose mythological and biblical scenes, he also developed a style of genre painting that was firmly grounded in the Classical tradition. His amazing technical proficiency, combined with a strong ability to infuse these works with a sentimental as well as a subdued erotic quality, made him a hugely successful artist among the bourgeoisie. As the model for such pictures as *A Young Girl Going to the Spring*

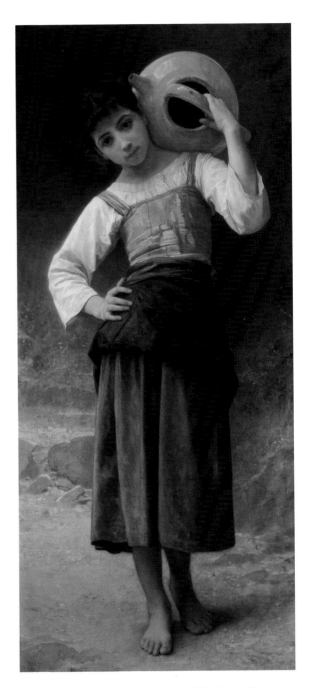

Fig. 30. William Bouguereau, *Young Girl going to the Spring* (or *The Water Girl*), 1885. Oil on canvas, 160.3 x 73.3 cm (63⅛ x 28⅞ in.). Dahesh Museum of Art, 1995.1

(1885; fig. 30) he employed a girl from his native La Rochelle, yet depicted her body in a pronounced S-curve that paid tribute to ancient sculpture. Moreover, the water jug is easily connected to the iconography of river gods, who are usually represented as human figures holding a jug from which water runs. In Ingres's famous painting *The Source* (1856, Paris, Musée du Louvre), a more traditionally Neoclassical

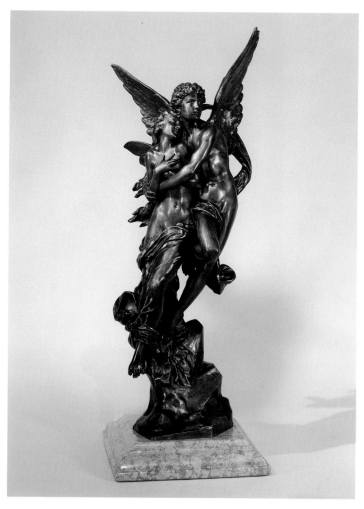

Fig. 31. Henri Godet, *The Abduction of Psyche*, ca. 1896. Bronze, 85.1 x 30.5 x 27.9 cm (33½ x 12 x 11 in.). Dahesh Museum of Art, 1995.30

and this specific two-dimensional representation of Cupid abducting Psyche translated comfortably into a three-dimensional form. Godet's challenge to represent a gravity-defying figural group is successfully realized in the modeling of cupid. Apart from his pointed wings and upward gaze, there are the bulging drapery, his curved body and his bent right knee. Ready to take Psyche into higher spheres, the materiality of the heavy bronze is surpassed. Unknowingly, Bouguereau further came to the sculptor's aid by depicting a rock formation in the lower part of the composition, translated by Godet into the base and support for his figures. This adaptation from a two-dimensional into a three-dimensional work of art was not an isolated instance. Figures from paintings by Gérôme, for example, were also transformed into sculptures and were, like reproductive prints and photographs, another way of marketing popular images and artists.[42]

The allegorical statue *Night* (1862) is a rare work by the Italian sculptor Raffaelle Monti (1818–1881), made from a then new material called Statuary Porcelain, or Parian (fig. 32).[43] The British firm Copeland and Garrett had developed this type of porcelain around 1845 in order to reproduce marble sculpture. Having worked in Milan and Vienna, Monti eventually settled in London where he lived most of his career. Apart from making sculptures in marble, and others cast in various metals, he also became much involved with the applied arts. Not only did he create strictly Neoclassical sculptures, he also favored a technical virtuosity that guided him towards a more Baroque dynamic. Illustrative in this respect is the recurring theme of veiled figures in his work. Thus, *Night* rests on a drum-shaped base that contains a Neoclassical decorative scheme, whereas the female figure hovering over the sleeping baby is a veritable *tour de force* of audacious modeling. A catalogue of the 1862 London International Exhibition, featuring *Night* with its pendant *Morning* (whereabouts unknown), describes the pair as follows: "The very striking and beautiful figures in statuary-porcelain, also engraved

interpretation of the same concept, a nude woman emptying a water jug from her shoulder is depicted in a similar pose. Bouguereau's rustic interpretations resounded extremely well to rich collectors in Europe and in the United States, as they were less threatening to their conventions than the more gritty and socially aware Realist peasant subjects painted by Gustave Courbet (1819–1877).

Henri Godet (1863–1937) transformed the Classical canon in a completely different way with his sculpture *The Abduction of Psyche* (ca. 1896; fig. 31). Undoubtedly inspired by Bouguereau's large picture of the same title (private collection)—the sculpture's base reads *W. BOUGUEREAU P. / H. GODET SCPT / Salon des Beaux-Arts 1896*—it was now Bouguereau himself who became the "classic" model to be emulated.[41] Demonstrating the painter's fame, such popular images found a ready market in various media,

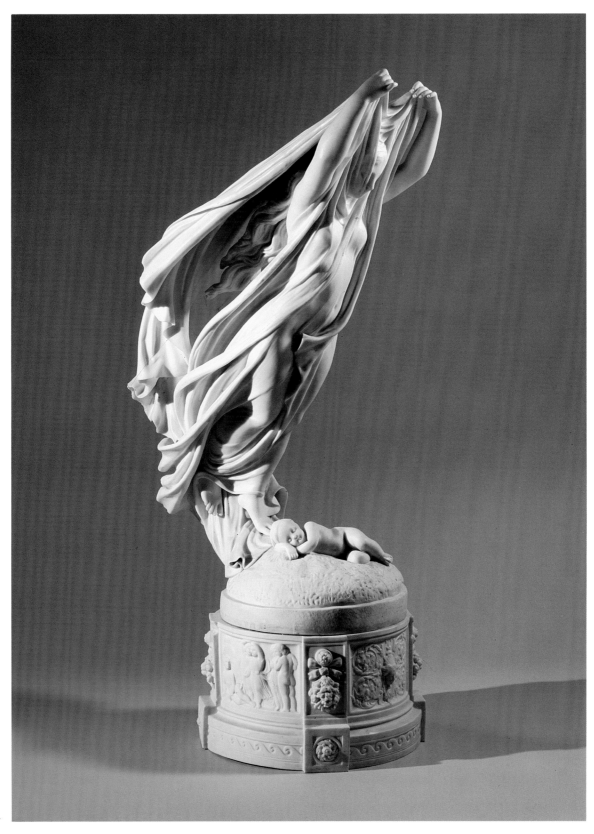

Fig. 32. Raffaelle Monti, *Night*, 1862. Statuary porcelain, height incl. base 68 cm (26¾ in.) Dahesh Museum of Art, 2001.9

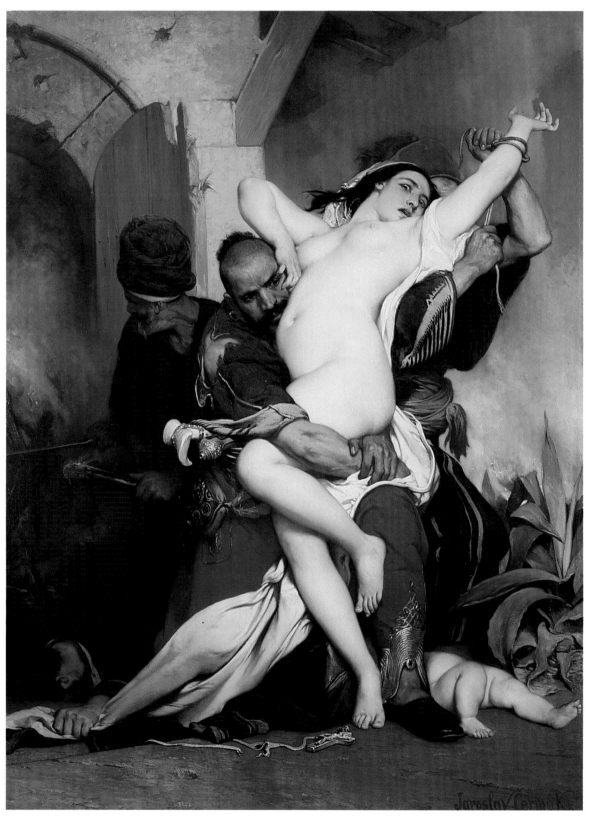

Fig. 33. Jaroslav Čermák, *The Abduction of a Herzegovenian Woman*, 1861. Oil on canvas, 250 x 190.5 cm. (98.5 x 75 in.). Dahesh Museum of Art, 2000.19

Fig. 34. Photo by Michelet, *The Salon of 1861*, showing the painting by Jaroslav Čermák in the lower left corner. (Photo courtesy Documentation du Musée d'Orsay, Paris.)

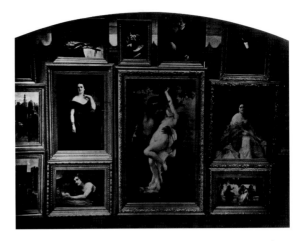

Fig. 35. Photo by Michelet, *The Salon of 1861*, showing *A Faun abducting a Nymph* by Alexandre Cabanel in the center (presently, Lille, Musée des Beaux-Arts). (Photo courtesy Documentation du Musée d'Orsay, Paris.)

on this page, represent Night and Morning and are models by Monti: they also are evidences of difficulties overcome—difficulties that can be appreciated only by those who understand the process through which such productions must pass (being, moreover of one piece) before they are finished."[44]

A work by the Czech painter Jaroslav Čermák (1830–1878) is a final example of how the Classical vocabulary has persevered under many different guises. Even though *The Abduction of a Herzegovenian Woman* (1861; fig. 33) is more conveniently characterized as a Romantic and Orientalist work, the composition is nonetheless heavily indebted to the long tradition of representing mythological abduction scenes. Giovanni Bologna's *Rape of a Sabine* (1582, Florence, Loggia dei Lanzi), or Bernini's *The Rape of Proserpine* (ca. 1622, Rome, Galleria Borghese) immediately come to mind. A similar theme, *The Abduction of Europa*, appears in the Museum's carved wood relief by Louis Ardisson (fig. 20). For centuries these and similar stories provided history painters and sculptors with subject matter that enabled them to depict the female nude in a complicated pose of torment. It is in this light that the critic Hector de Callias reviewed Čermák's painting in *L'artiste* of 1861, when exhibited at the Paris Salon (fig. 34):

> [it] enabled him to make a study of the nude in a modern subject. This painting is one of the best of the Salon. The woman being abducted is well rendered and painted with assurance. With four figures, the artist knew how to express the feel-

ing of a grand scene of desperation, which is something others don't always achieve with a huge crowd.[45]

At the 1861 Salon, the painting bore the title *Razzia de bachi-bouzouchs dans un village chrétien de l'Herzégovine (Turquie)*. Bashi-bazouks were irregular troops attached to the Ottoman army and feared for their ferocity. In this unsettling, extremely evocative image, a naked woman is being abducted by the murderers of her baby and husband, whose bodies lie on either side of her. A third intruder is about to set the building in the background on fire. Apart from the Salon title, the crucifix with a torn chain lying in the foreground leaves little question about the religious convictions of the woman. Thus the painting presents the "Ottoman threat" to "Christian civilization." This horrific scene reflected the actual political turmoil in the region, as Čermák had witnessed Turkish troops attacking villages in Central Europe. As an image of war-related atrocities generated by the political, ethnic and religious conflicts in that very area, the work unfortunately continues to have modern reverberations. The same Salon also featured Alexandre Cabanel's famous *Nymph Abducted by a Faun* (1860, Lille, Musée des Beaux-Arts; fig. 35), displaying a great thematic and compositional kinship with Čermák's work, yet devoid of the political implications. The caricaturist Galetti was not the only one who picked up on this kinship (fig. 36),[46] and Laurent-Pichat, in his Salon review, made the following comparison:

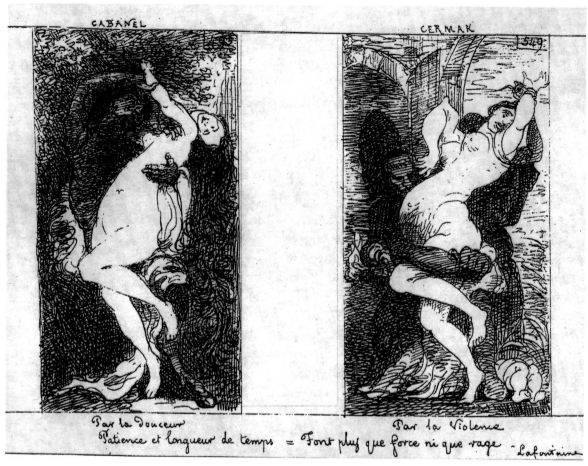

Fig. 36. Galetti, *Salon de 1861, Album caricaturale* (Paris 1861). Text under Cabanel: *Par la douceur* [By gentleness], text under Čermák: *Par la violence* [By force]. Text under both: *Patience et longueur de temps = Font plus que force ni que rage. Lafontaine* [Patience and waiting—are more effective than force and rage. Lafontaine]. (Photo courtesy Documentation du Musée d'Orsay, Paris.)

The *Nymph Abducted by a Faun* is one of the important pieces of the exhibition. It's audaciously done with a passionate movement. The forms of the woman are treated to perfection. We reproach some limpness to the legs of the faun. The effort and the spirit of desire that animate him should provide them with more nerve. This weakness only becomes apparent after a long contemplation of the picture. [...] Mr. Jaroslaw Čermák also painted his razzia; it is an expedition of Bachi-Bouzoucks in a Christian village in Herzegovina. It is less mythological, truer, and therefore sadder. But the picture by the painter from Prague holds up well against that of Cabanel. There are qualities of strength that we appreciate above the others, and no exaggeration.[47]

Théophile Gautier also paid an astute tribute to the picture. Being somewhat of an Orientalist himself, he argued that the scene is not merely the prelude to a rape by the woman's captors, but that in order to retain her value on the slave market they would not be violating her. That this was ultimately no real benefit to the victim is of course conveniently ignored. Yet, Gautier correctly noted that Čermák succeeded in making a strong composition with a magnetic force. Indeed, the central figural group conveys a formidable presence, and only a more careful scrutiny of the composition releases the full impact of the horrific event:

Une Razzia de Bachi-bouzoucks in a Herzegovenian village by Mr. Čermák imperiously attracts the eye by means of a certain forceful and luminous brutality. To sell her to some seraglio, a

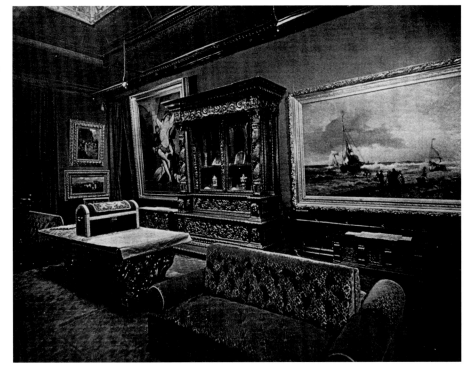

Fig. 37. *The Art Gallery*, from the auction catalogue: *The Gallery of Modern Painters contained in the Residence of the Late Mrs. Emelie de L. Havemeyer (Widow of the Late Theodore A. Havemeyer)*, American Art Galleries, New York, November 18, 1914.

bachi-bouzouck with a shaved head abducts a beautiful young naked woman, who twists herself in his arms and scratches him. One sees from the tenacious impassivity of the abductor that he is more concerned with the gold purses of Djellab than with the charms of his victim. He would rather not endanger his valuable prize that struggles and doesn't care whether she gets wounded. At the foot of this group lies a massacred child whose cries had been disturbing. In the background, other bachi-bouzoucks are setting the plundered houses ablaze. These details are more apparent in the description than in the painting itself, where the torso of the woman monopolizes the eye with the vivid brightness of tone and the spirited luxurance of the flesh. It is a beautiful piece, this body full of strength, youth and health, lavishly female and with a satin sheen. [...] This exhibition is as far as we know the debut of Mr. Jaroslav Čermák. Immediately he knew how to distinguish himself from the crowd, and make himself noticed amongst this avalanche of pictures. At the Salon, it is not enough to have talent, one has to make sure that this talent is visible [*visible*], or rather noticeable [*voyant*], to talk in the jargon of our time.[48]

As can be expected, not everyone was equally laudatory about the work.[49] But, as Gautier said, it was not a painting that could easily be ignored, and consequently the artist had attracted attention. As a history painter, Čermák often depicted Bohemian subject matter in such works as *The Counter-Reformation* (1854), or *Hussites Defending a Farm Track* (1857) (both Prague, National Gallery). The resistance against Turkish rule in his homeland was another recurring theme, as is seen in the Dahesh painting. In 1848, Čermák began his training with Christian Ruben (1805–1875) at the Prague Academy, and continued his studies a year later under Gustave Wappers (1803–1874) in Antwerp and Louis Gallait (1810–1887) in Brussels. In 1851 he settled in Paris and eventually traveled widely throughout Europe, including the Slavic regions. A product of many different influences, Čermák expressed himself in a mixture of late French Romantic as well as Realist styles. After the 1861 Salon, at which the artist received a medal, *The Abduction of a Herzegovenian Woman* was widely exhibited throughout Europe (Rouen 1864; Berlin 1866; Brussels and Munich 1869). Apparently first owned by the dealer Goudsmit in The Hague around 1870, it went to Baron Gerspach in Paris, who bought it for an Ameri-

can collector, probably Theodore A. Havemeyer in New York, one of the important Gilded-Age collectors in the United States (fig. 37). The acquisition of this picture by the Dahesh Museum of Art represents an appropriate homecoming for one of New York's lost academic treasures.

Edward Strahan singled out this painting when discussing Theodore Havemeyer's collection in *The Art Treasures of America* (1879): "[Of his many paintings] perhaps the palm should be awarded to the fine *Episode in the Massacre of Syria* [sic] by Jaroslav Čermák, that admirable painter who seemed to unite the keen objective perceptions of the Gypsy with the refinements of western culture."[50] Strahan's elaborate description in florid prose indicates why this picture—which may seem offensive to today's audience—is in fact a vivid reminder of how art not only serves aesthetic purposes but also often has moral and political implications. Such issues were then, and still are today, very much a matter of interpretation. Strahan's praise of the picture is integrally linked to its place in the defense of Western Culture:

His present picture is a noble and, as it were, monumental pyramidal composition, composed of a woman struggling in the arms of soldiery. Her towering white form rises in a superb attitude of stormy grace, as she strives, with the strength of a grand and richly-developed nature, to free herself from the grasp of the warlike captors. Her husband, slain at her feet, still grasps convulsively the hem of her garment. A lusty babe, also dead, lies near by. Alone now on earth, with nothing to live for but honor, she concentrates her thoughts on the single idea of liberty, and struggles with hands and feet to free herself from the powerful foes who are carrying her away captive. Her posture, in this great passion of energy, is full of native grace, the rich beauty of the animal nature asserting instinctively its wild sense of justice. While an old soldier guards the door with his sword against intruders, a powerful shaven-headed infidel clasps her with fell purpose in the rigid vise of his wiry arms, and another begins to tie her wrists. One beautiful arm—alas, that so soft a limb should feel the outrage of a rope!—is already encircled with its hempen manacle, though she brandishes it aloft with all her strength. The other hand and arm, white as the

swan's wing, are resolutely battling with the Moslem monster who imprisons her in his grasp; the convulsive movements of the beautiful feet add to the dramatic expression of the figure, which equals, in artistic technical beauty, in rich *morbidezza*, in sinuous and flexible grace combined with robustness, the most daring sculpture of John of Bologna or any of the complicated designers of the Renaissance. All around the white Rubenesque grandeur of her torso, and forming a rich foil, are relieved the dark skins and braided garments of her captors, who themselves yield us glimpses of savage tawny faces, in the highest degree spirited and expressive. At the foot of the unhappy captive lies her carved crucifix, whose string has been torn from her neck in the struggle; so that she rises, and aspires, and battles, and achieves, like a living allegory of Christianity,—assailed, insulted, borne hither and thither, but not yet conquered. Čermák's qualities, as seen in this picture, are a noble and commanding breadth of style, a serenity of purpose and sagacious subordination of details in the midst of the hot energy of his conception. Some of Titian's stormier scenes have this velocity of *brio*, combined with this serenity of perception. There is hardly a living painter of the world who might not have been proud to sign the picture.[51]

Strahan's unabashed interpretation leaves no doubt that for him the painting was to be read as an ode to Western civilization, which needed to be defended from "powerful foes" or, as he put it in an even more offensive term, the "Moslem monster." Thus the naked female body was not merely to be seen as an object of lust, but it represented for Strahan the very notion of pure and superior Western culture. For his American audience, the conceptual parallel to one of the most famous sculptures in 19th-century American art, Hiram Powers' *The Greek Slave* of 1844, must have been evident. This life-size marble of a perfectly shaped female nude, with her hands tied in chains, also implies a contemporary Greek woman captured by Turks and sold into slavery.[52] Far more serene a composition than the Čermák, both works nonetheless addressed similar aspects of clashing cultures and religions (the marble also shows a small crucifix). Strahan himself made the formal connection with *The Rape of a*

Sabine by Giovanni Bologna, an analogy that here supersedes mere formalism. It is again the notion that Classical and Renaissance art represented the noblest of both form and idea, similar to Winckelmann's belief that the Greeks made sublime art as a result of their perfect society. It is in this context that Čermák's picture exemplifies how most 19th-century works of academic art—or the interpretations thereof—are in one way or the other rooted in the Classical tradition.

Roger Diederen
Associate Curator

ACKNOWLEDGMENTS

I wish to thank the Museum's Director J. David Farmer, the Associate Director Michael Fahlund, and my curatorial colleagues Stephen Edidin and Lisa Small, for entrusting me with organizing the accompanying exhibition and letting me write this catalogue. Their suggestions and discussions, as well as the agreeable collaboration with all other Museum staff made this a most rewarding project to work on.

I am also grateful to Dominique Lobstein, Documentaliste at the Documentation of the Musée d'Orsay in Paris, for so generously answering all my research questions. His help is much appreciated and made this text far more accurate than it otherwise would have been.

Finally, I would very much like to thank the members of the Museum's Board of Trustees for their trust and support, and for answering the Riddle of the Sphinx!

—R. D.

NOTES

1 Moreau-Vauthier, 1906, 176: "Durant la première semaine de travail, le modèle, dans l'atelier Gérôme, fut un Antique, le *Germanicus*." On the Classical statue, see: Francis Haskell and Nicholas Penney, *Taste and the Antique. The Lure of Classical Sculpture* (New Haven / London 1981), pp. 219–20.

2 Gerald M. Ackerman, "The Bargue-Gérôme *Cours de dessin*: Goupil & Cie Attacks a National Problem," in: *Gérôme & Goupil. Art and Enterprise*, exh. cat. Bordeaux, Musée Goupil; New York, Dahesh Museum of Art; Pittsburgh, The Frick Art & Historical Center (2000–2001), pp. 55–66. [French and English language editions.] The official titles of the course and its individual volumes are: *Cours de Dessin, exécuté avec le concours de Gérôme* (Paris, Goupil & Cie, 1868–70), [Drawing course, executed in collaboration with Gérôme]. Vol. I: *Modèles d'après la bosse* [Models in the round (i.e. sculpture)]. Vol. II: *Modèles d'après les maîtres de toutes les époques et toutes les écoles* [Models after the masters of all the ages and all schools]. Vol. III: (without Gérôme's name on the title page) *Exercices au fusain pour préparer à l'étude de l'académie d'après nature*. [Exercises in charcoal, in preparation for studying the live model]. The first two volumes were primarily intended for students at schools of (industrial) design, who were not expected to become full-fledged history painters. The third volume was for art academies and home study.

3 The Dahesh Museum of Art owns a painting by Lecomte du Nouÿ, *Judith* (1875), which is included in the companion catalogue *Telling Tales II: Religious Images in 19th-Century Academic Art* (2001). It is also featured in *Highlights from the Dahesh Museum Collection* (New York 1999), p. 44.

4 Guy de Montgailhard, *Lecomte du Noüy* (Paris 1906), pp. 14, 114 (under the year 1865).

5 The text on this plate from the *Cours de Dessin*, however, claims that the horse derives from the "*Fronton occidental*" (West pediment).

6 Three of these plates are kept in the Bibliothèque Nationale, Paris, Département des Estampes (DC 309 II), with autograph inscriptions by Lecomte du Nouÿ indicating that the lithographs were made after his drawings.

7 Gérôme gave Michelangelo the same features as the severed head of Holofernes in the Sistine ceiling, which has been interpreted as a self-portrait of the artist. John T. Paoletti, "Michelangelo's Masks," *The Art Bulletin* (September 1992), pp. 423–40. The painter Joseph-Nicholas Robert Fleury made a drawing of Michelangelo waking near his ill servant, in which the artist is given the exact same features. The related painting by Robert Fleury (whereabouts unknown) was exhibited at the 1841 Salon. The drawing is reproduced in the exhibition catalogue: *De Michel-Ange à Géricault*, Paris, Ecole Nationale Superieure des Beaux-Arts (1981), no. 159.

8 Haskell and Penney (1981), op. cit. note 1, pp. 311–14.

9 Francis Haskell, *The Most Beautiful Statues: the Taste for Antique Sculpture, 1500-1900*, exh. cat. Oxford, Ashmolean Museum (1981), no. 47.

10 Gerald M. Ackerman, "The Néo-Grecs: A Chink in the Wall of Neoclassicism," in: June Hargrove, ed. *The French Academy. Classicism and its Antagonists* (1990), pp.168–95.

11 In the latest edition of Gérôme's oeuvre catalogue, this paint-ing is mistakenly listed as dating from 1895, whereas in fact it is dated 1890. The Dahesh painting most likely precedes the version in the Haggin Museum, Stockton CA. Gerald M. Ackerman, *Jean-Léon Gérôme* (Paris 2000), no. 419.3.

12 Gerald M. Ackerman, "Gérôme's Sculpture: The Problems of Realist Sculpture," *Arts Magazine* (February 1986), 82–9. Andreas Blühm, et al., *The Colour of Sculpture 1840–1910*, exh. cat. Amsterdam, Van Gogh Museum; Leeds, Henry Moore Institute (1996). The Dahesh Museum of Art published a small brochure that accompanied the exhibition *Jean-Léon Gérôme and the Classical Imagination* (October 22, 1996–February 15, 1997).

13 Some are reproduced in: Jean Pierre Cuzin, et al. *D'après l'antique*, exh. cat. Paris, Musée du Louvre (2000-2001), p. 399 ff.

14 The auction catalogue of Christie's, New York, May 22, 1996, lot 226, states that the man dressed in black, seated at the left is Jean de Cabanes, also known as Cabaner. A clear argumentation for this statement, however, is lacking.

15 For a discussion of this sculpture see June Hargrove in, *The Romantics to Rodin. French Nineteenth-Century Sculpture from North American Collections*, exh. cat. Los Angeles County Museum of Art; and traveling (1980), pp. 164–66.

16 Charles Avery, *Fingerprints of the Artist. European Terra-Cotta Sculpture from the Arthur M. Sackler Collections* (Cambridge 1988), pp. 220–22. I would like to thank June Hargrove for providing me with this reference.

17 For more elaborate information on the various casts, see: Jean-Loup Champion, Charles Janoray, *Antiquity Revisited. The Classical Tradition in Sculpture from Houdon to Guillaume*, exh. cat., New York, Charles Janoray LLC (Oct. 12—Nov. 15, 2000), p. 32. See also, Claude Lapaire, "Sapho debout," *Bericht über die Tätigkeit der Eidgenössischen Kommission der Gottfried-Keller Stiftung, 1993-1996*, pp. 29–32.

18 Théophile Gautier, "Salon de 1848 (deuxième article)," *La Presse* (21 April 1848), "La *Sapho*, comme pour faire pendant à la *Nyssia* [1848, Musée de Grenoble] est entièrement vêtue. Une souple draperie, flottante et precise comme celle de la *Mnémosyne* ou de la *Calliope*, enveloppe son corps dont elle voile les formes tout en les accusant. [...] La tête s'incline pensive et douloureuse, courbée sous l'amer chagrin d'un amour méconnu. Au bas, sur le pli de la robe s'ébattent et se becquetent deux colombes; inutile offrande qui n'a pas désarmé Vénus! Jamais Pradier qui, à l'exemple des Anciens, n'aime pas à troubler la beauté des traits par l'expression de la joie ou de la douleur, n'a fait une physionomie aussi significative; ordinairement, il concentre la vie dans le torse qui est pour lui le principal du corps humain. La predominance de la tête sur le reste du corps est un sentiment spiritualiste et chrétien ignoré de l'antiquité, et Pradier est un payan pur, adorateur de Zeus, d'Héré, de Poséidon et surtout d'Aphrodite. Cette fois, comme la draperie couvrait les portions qu'il excelle à rendre, il a donné plus d'importance au masque, et la pensée en crispe les sourcils d'airain; du reste, Sapho la grande poétesse méritait bien qu'on logeât une âme sous le front et le sculpteur lui a laissé assez de beauté pour rendre incompréhensible le saut du rocher de Lecaute. [...] Cette statue demi-nature, si elle était convenablement oxydée et vertdegrisée par un séjour prolongé sous la terre ou dans la mer, qui lui donnerait la

patine antique, pourrait passer pour une des oeuvres du beau temps de l'art grec ou romain, et se paierait des prix incalculables." Cited from: *Statues de Chair. Sculptures de James Pradier (1790–1852)*, exh. cat. Geneva, Musée d'art et d'histoire; Paris, Musée du Luxembourg (1985–86), pp. 156–57.

19 For an extensive exploration of how the *Venus de Milo* in particular (and ancient art in general), influenced future generations of artists, see: *D'après l'antique*, op. cit., note 13, pp. 432–99.

20 Dominique Lobstein, "A Mysterious 'Salon.' The Vienna International Art Exhibition of 1882 by Wilhelm Gause." *Apollo* (February 2001), pp. 39–46. In this article Mr. Lobstein intelligently identifies the subject of the painting, as well as many of the works of art depicted.

21 For splendid illustrations of these works, see: John Pope-Hennessey, *An Introduction to Italian Sculpture. Vol. III, Italian High Renaissance & Baroque Sculpture* (London 2000), plates 37, 46–7, 87.

22 "François-Xavier Fabre, peintre et collectioneur," *L'Estampille/L'Objet d'Art*, Numéro Spécial 2 H (2000).

23 The Dahesh Museum of Art owns a marble bust by Bosio, entitled *The Virgin Mary* (1843). This serene female head of transcendental beauty is clearly modeled after Classical proportions. Only the indication of the neckline of a dress and the title make it a religious work. It is featured in the companion catalogue to this publication, *Telling Tales II: Religious Images in 19th-Century Academic Art* (2001).

24 Michel Poletti and Alain Richarme, *Barye. Catalogue raisonné des sculptures* (Paris, Gallimard, 2000), pp. 109–11. See also, Glenn F. Benge, *Antoine Louis Barye. Sculptor of Romantic Realism* (Penn. State Univ. Press 1984), pp. 48–49, 115–16.

25 Pope-Hennessey, op. cit., note 21, plate 139.

26 *Explication des ouvrages de peinture, sculpture, [...] exposés aux Palais des Champs-Élysées* (1 Mai, 1864), p. 130, Gendron (Auguste), né à Paris, élève de Paul Delaroche. Méd. 3e cl. (Genre Historique) 1846 et 1855—Méd. 2e cl. 1849. [Légion d'Honneur] Nov. 1855—[ex.]. Rue St Honoré, 408. No. 785 Les nymphes au tombeau d'Adonis. "Quand l'astre de la nuit éclaire ce feuillage / Un doux sommeille succède à leurs gémissements."

27 On the Palais d'Orsay, see: *Du palais au palace. Des grands hotels de voyageurs à Paris au XIXe siècle*, exh. cat., Paris, Musée Carnavalet (1998-99), pp. 162-173. The ceiling and a preparatory sketch by Ferrier are reproduced on pp. 172–73.

28 The title of this work derives from a French handwritten inscription (*Le bain de Diane*) on a paper label adhered to the stretcher. When sold at the atelier sale at Drouot, Paris, 18 November 1981, lot 151 (reproduced), the painting was given the title *La Toilette de Flore*.

29 This other composition is reproduced in: André Michel, *Peintures et Pastels de René Ménard* (Paris 1923), p. 52, *Le bain de Diane* (1920); p. 74 also lists a work from 1920, *Le bain de Diane* (pastel; grande figure).

30 Christopher Forbes, *The Royal Academy Revisited. Victorian Paintings from the Forbes Magazine Collection New York*, exh. cat., New York, Metropolitan Museum of Art; and traveling (1975), pp. 90-91, "Bacchante." The DMA drawing is reproduced partially.

31 They measure 133.5 x 424.5 cm, and 197 x 407 cm respectively, and are discussed and reproduced in *Frederic Leighton*, exh. cat., London, Royal Academy (1996), cat. nos. 34, 95.

32 *The Art Journal* (London 1902), p. 212.

33 Vern Swanson, *The Biography and Catalogue Raisonné of the Paintings of Sir Lawrence Alma Tadema* (London 1990), the DMA drawing is reproduced on p. 64; see also cat. nos. 305, 347.

34 The artist gave opus numbers to paintings he deemed accomplished. Thus he could keep a clear record of his oeuvre and make it more difficult for others to produce fakes.

35 *The Illustrated London News*, vol. 57 (December 3, 1870), p. 566.

36 This unpublished manuscript is kept in the Printroom (Rijksprentenkabinet) of the Rijksmuseum in Amsterdam. I would like to thank Mr. Freek Heijbroek for providing me with the information. The comment reads: "*ex.*[écuté] *p.*[our] *l'Exposition de tombola à l'aide du paysan français.*"

37 *The Illustrated London News*, vol. 57 (December 24, 1870), p. 639.

38 Louise d'Argencourt, Roger Diederen, et al., *The Cleveland Museum of Art, Catalogue of Paintings. Part four: European Paintings of the 19th Century* (1999), pp. 4–7. The photograph by Sommer is reproduced here, as well as in *Highlights from the Dahesh Museum Collection* (New York 1999), p. 68.

39 This collection of photographs is still completely intact and is kept at the University of Birmingham, Great Britain.

40 Edward Bulwer, Lord Lytton, *The Last Days of Pompeii*, 2d ed. [Leipzig 1879], p. x.

41 Louise d'Argencourt, et al., *William Bouguereau*, exh. cat., Paris, Musée du Petit Palais; Montreal Museum of Fine Arts; Hartford, Wadsworth Atheneum (1984–85), cat. no. 131 [French and English language editions]. The painting is also reproduced in Fronia Wissman, *Bouguereau* (San Francisco, 1996), plate 60.

42 See the exhibition catalogue *Gérôme & Goupil, Art and Enterprise*, op. cit. note 2, especially chapter III: Florence Rionnet, "Goupil and Gérôme: Two Views of the Sculpture Industry," pp. 45–53.

43 See Paul Atterbury and Maureen Batkin, eds. *The Parian Phenomenon: A Survey of Victorian Parian Porcelain Statuary & Busts* (1999).

44 *The Art Journal Illustrated Catalogue of the International Exhibition 1862* (London 1862), p. 169.

45 Hector de Callias, "Salon de 1861," *L'Artiste*, XI (1861), p. 245: "M. Čermák a reproduit d'un pinceau exercé des types de raïas et de femmes gréco-slaves; mais sa *Razzia de bachibouzouks* a été pour lui une bonne fortune, en ce qu'elle lui a permis de faire une étude de nu dans un sujet moderne. Ce tableau est un des meilleurs du Salon. La femme qu'on enlève est bien jetée et peinte avec sûreté. Avec quatre personnages l'artiste a su donner le sentiment d'une grande scène de desolation, ce à quoi d'autres ne réussissent pas toujours avec toute une foule."

46 Canteloube refers to this very caricature in his Salon review and thus also makes the comparison between the Cabanel and the Čermák. A. Canteloube, *Lettre sur les expositions et le Salon de 1861* (Paris 1861), p. 66.

47 L. Laurent-Pichat, *Notes sur le Salon de 1861* (Lyon 1861), p. 29: "*La nymphe enlevée par un faune* est un des morceaux importants de l'exposition. C'est audacieusement fait d'un mouvement bien passionné. Les formes de la femme sont traitées en perfection. Nous reprochons aux jambes du faune un peu de mollesse. L'effort et l'élan du désir qui l'anime devraient leur communiquer plus de nerf. Ce défaut n'apparaît qu'après que l'on a longtemps contemplé le tableau. [...] M. Jaroslaw Čermák a peint aussi sa razzia; c'est une expedition de Bachi-Bouzoucks dans un village chrétien de l'Herzégovine. C'est moins mythologique, plus vrai et par cela même plus triste; mais le tableau du peintre de Prague soutient la comparaison avec celui de M. Cabanel. Il y a des qualités de force que nous apprécions au-dessus des autres, et aucune exagération."

48 Théophile Gautier, *Abécédaire du Salon de* 1861 (Paris 1861), pp. 99–101: "*Une Razzia de bachi-bouzoucks* dans un village de l'Herzégowine, de M. Čermák, attire impérieusement le regard par une certaine brutalité puissante et lumineuse. Un bachi-bouzouck à tête rasée enlève, pour la revendre à quelque serial, une belle jeune femme nue qui se tord entre ses bras et l'égratigne. On voit à l'impassibilité opiniâtre du ravisseur qu'il pense plutôt aux bourses d'or du Djellab qu'aux charmes de sa victime. Il voudrait bien ne pas endommager cet objet de prix qui se débat sans souci des déchets et des meurtrissures. Au pied du groupe s'étale un enfant massacré dont les vagissements importunaient. Au fond, d'autres bachi-bouzoucks mettent le feu aux maisons saccagées. Ces details sont plus apparents dans la description que dans le tableau même, où le torse de la femme accapare l'oeil par l'éclat vivace du ton et de la fougueuse luxuriance de la chair. C'est un beau morceau que ce corps plein de force, de jeunesse et de santé, grassement feminin et satiné de lumière. [...] Cette exposition est, à ce qu'il nous semble, le début de M. Jaroslav Čermák. Du premier coup il a su se tirer de la foule, et se faire apercevoir dans cette immense cohue de tableaux. Au Salon, ce n'est pas le tout que d'avoir du talent, il faut encore que ce talent soit *visible* ou plutôt *voyant*, pour parler le jargon de la mode."

49 Maxime du Camp, *Salon de 1861* (Paris 1861); and, Émile Perrin, "Salon de 1861," *Revue Européenne* (1 June, 1861), pp. 585–86. Also, Albert de la Fizelière, *A-Z ou le Salon en miniature* (Paris 1861), pp. 17–18: "ČERMÁK (Jaroslaw), nos 549–52. Histoire et portrait. Un amateur ayant affaire à M. Courbet, monte un jour l'escalier du no 32 de la rue Hautefeuille; il frappe à une porte, un peintre vient ouvrir, la palette à la main.—Monsieur Courbet, s'il vous plaît?—Je ne connais pas ça, répond l'artiste; qu'est-ce qu'il fait, ce monsieur? M. Čermák serait en droit de faire la même réponse; car s'il connaît la peinture, il ne connaît certes pas cette peinture franche, ferme, puissante, énergique sans effort et savante avec simplicité qui fait le succès du peintre d'Ornans."

50 Edward Strahan, ed., *The Art Treasures of America. Being the Choicest Works of Art in the Public and Private Collections of North America* (Philadelphia 1879), p. 135. The painting is reproduced in a full-page black and white reproduction.

51 Idem.

52 For an extensive investigation of this marble, see: Joy S. Kasson, *Marble Queens and Captives. Women in Nineteenth-Century American Sculpture* (New Haven / London 1990), chapter III, pp. 46–72. Page 56 reproduces a print after the Čermák painting, giving it the title from Strahan's publication, *Episode in the Massacre of Syria*.